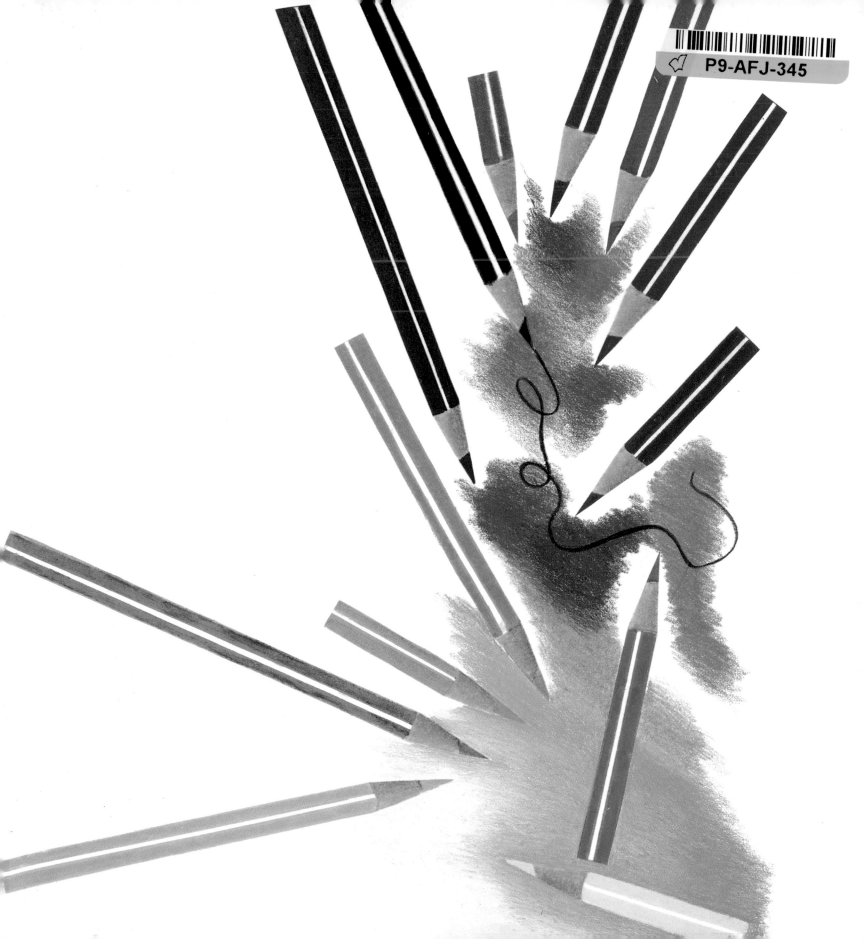

Love
to
Dick

•

Thanks
to
Judy Laird's Kindergarten,
Fair Oaks Elementary School,
Fair Oaks, California
for
finger paint
and
handprints

ISBN 0-590-69172-4

Copyright © 1995 by Ruth Heller.
All rights reserved. Published by Scholastic Inc., 555 Broadway, New
York, NY 10012, by arrangement with The Putnam & Grosset Group.

12 11 10 9 8 7 6 5 4 3 2 1 6 7 8 9/9 0 1/0

Printed in the U.S.A.

First Scholastic printing, February 1996

COLOR
COLOR
COLOR
COLOR

By Ruth Heller

Scholastic Inc.

New York Toronto London Auckland Sydney

From
pencils
and
markers
and
crayons

and
chalks . . .

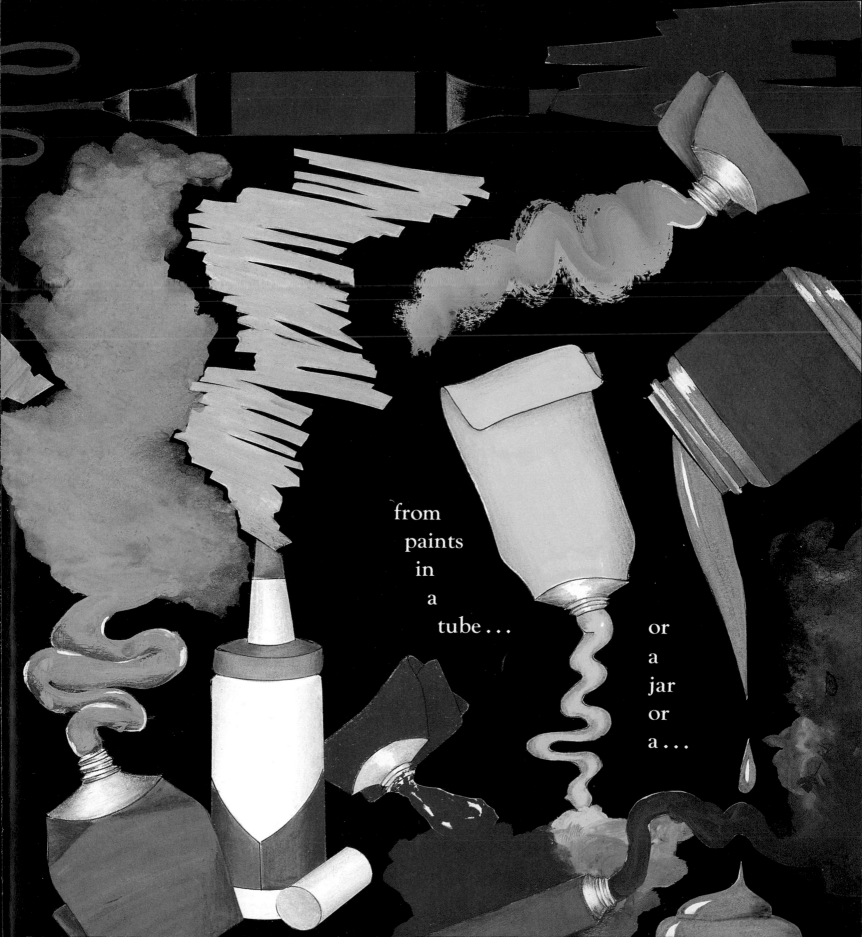

from
paints
in
a
tube . . .

or
a
jar
or
a . . .

box . . .

come
colors
delicious,
delectable,
lush . . .

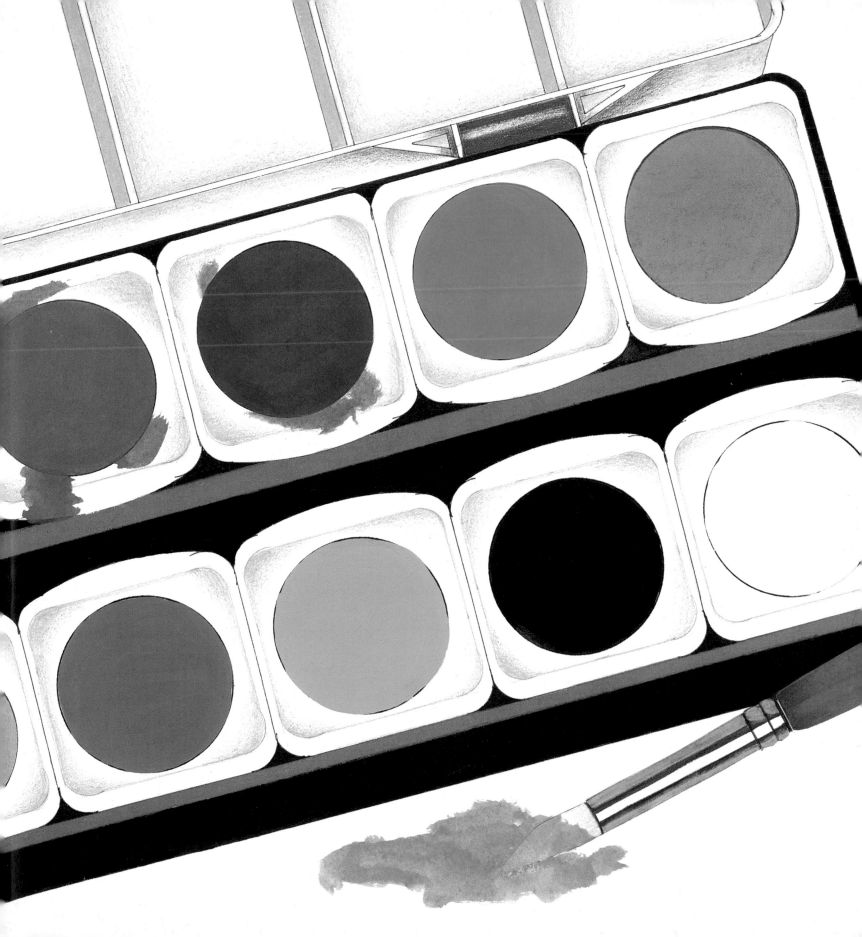

applied by ten fingers, two hands . . .

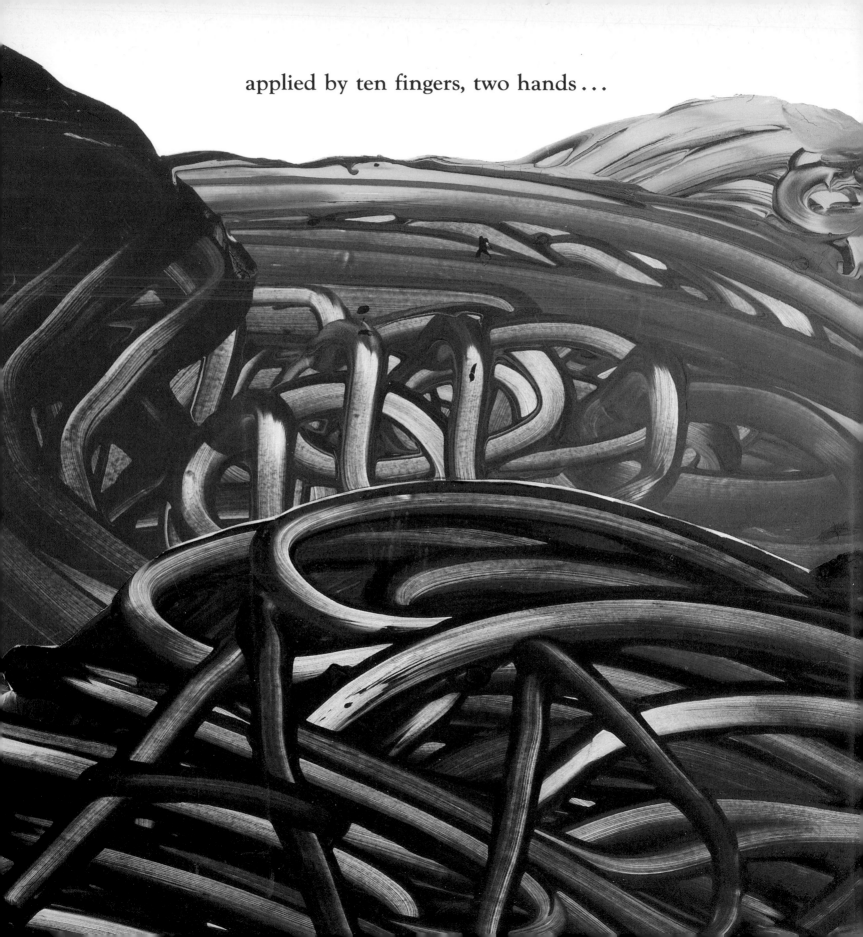

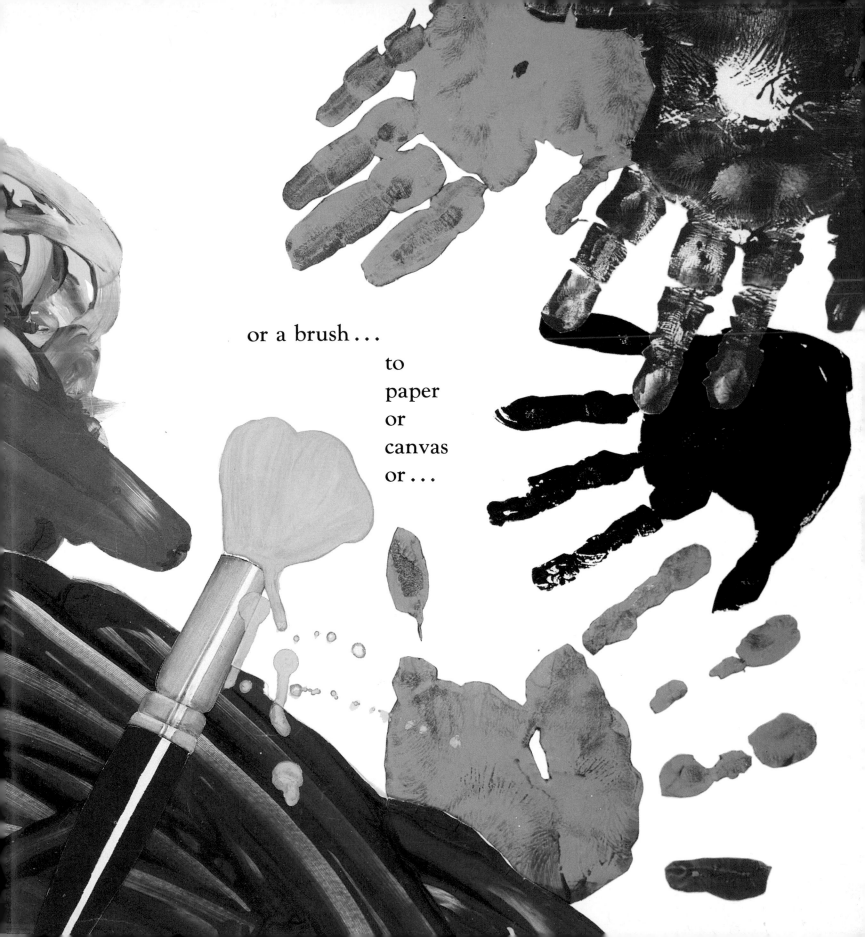

or a brush...
to
paper
or
canvas
or ...

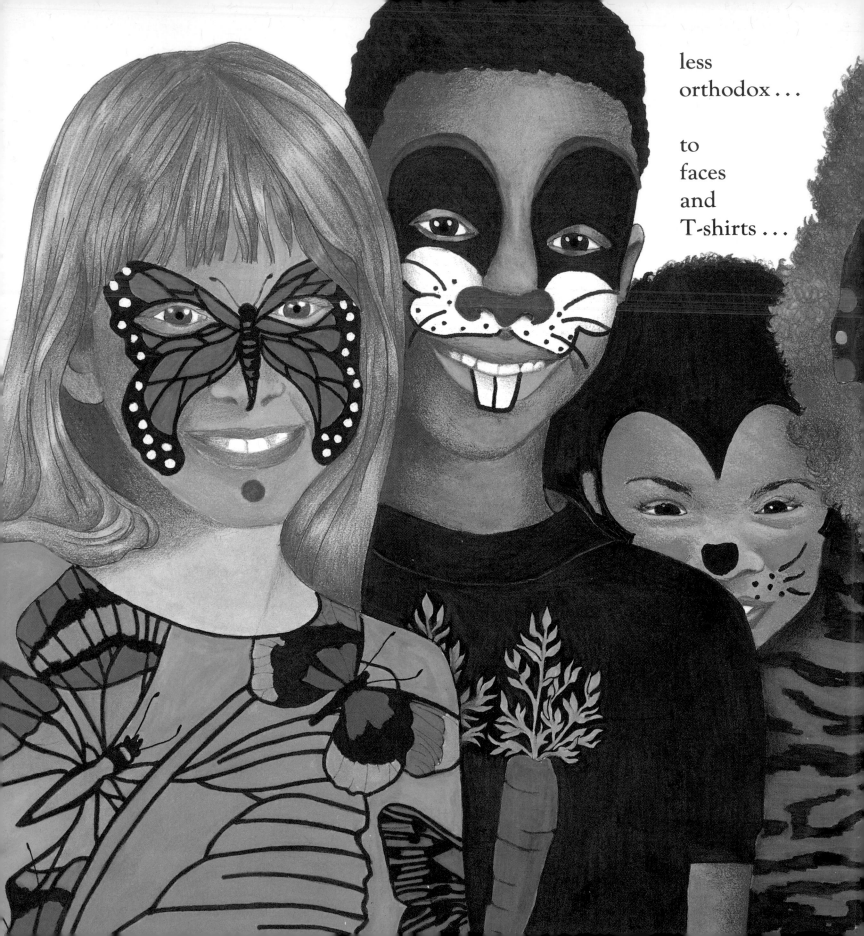

less
orthodox . . .

to
faces
and
T-shirts . . .

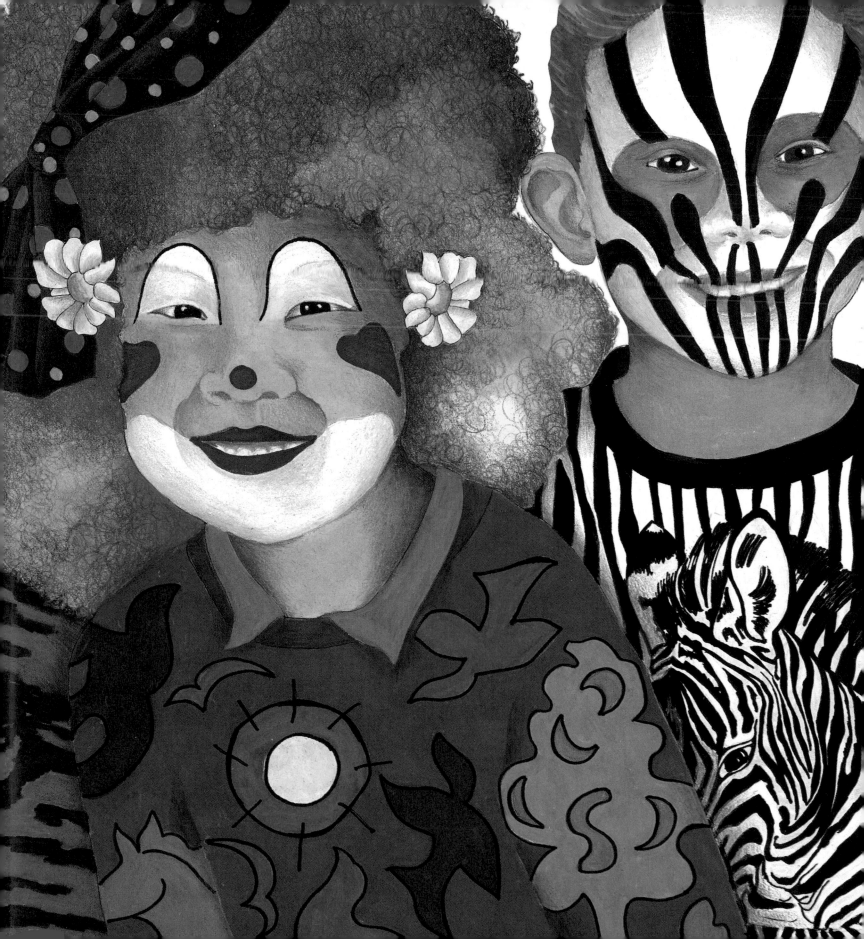

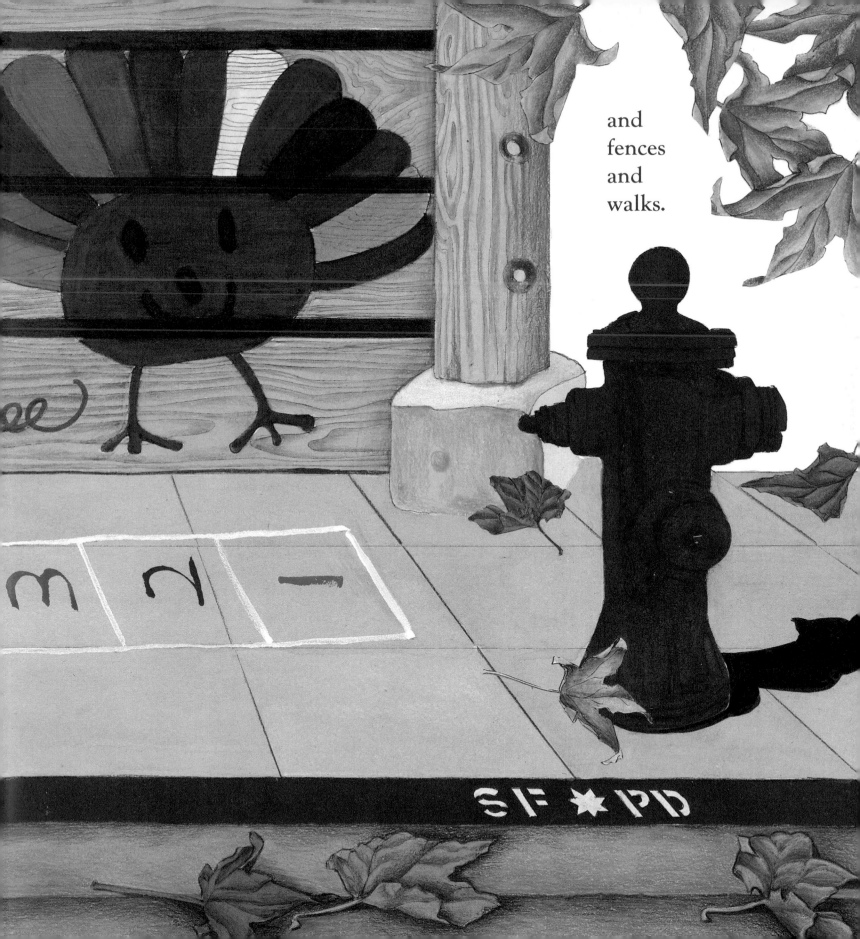

and
fences
and
walks.

Then . . . ABRACADABRA,

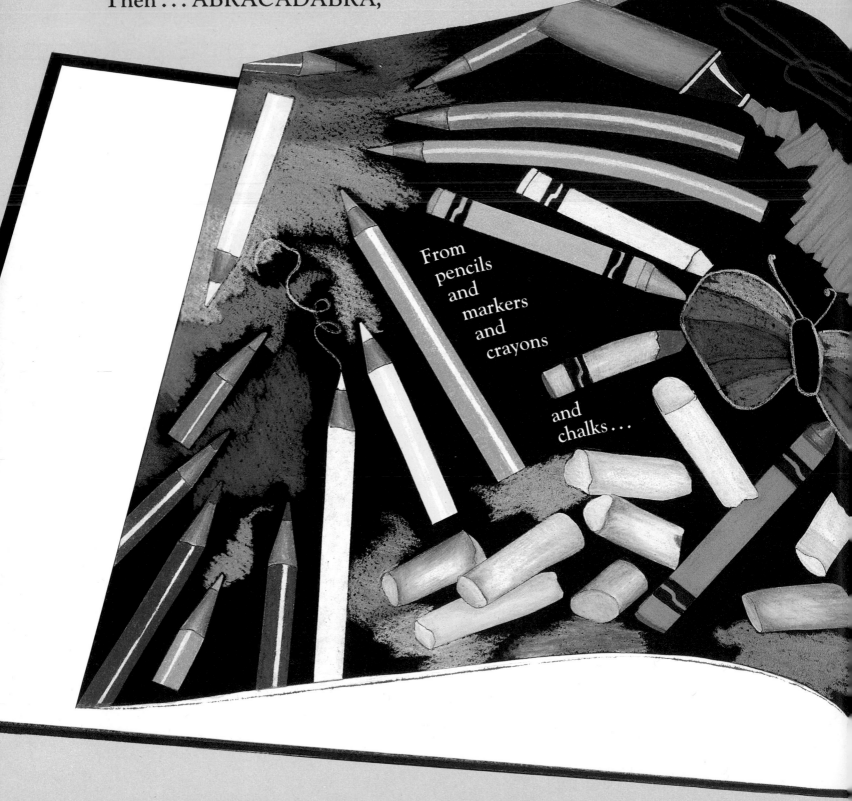

From
pencils
and
markers
and
crayons

and
chalks . . .

by hook and by crook...
every one of those colors got into this book.

They were printed by printers in four inky stages,
and now they appear right here
on these pages.

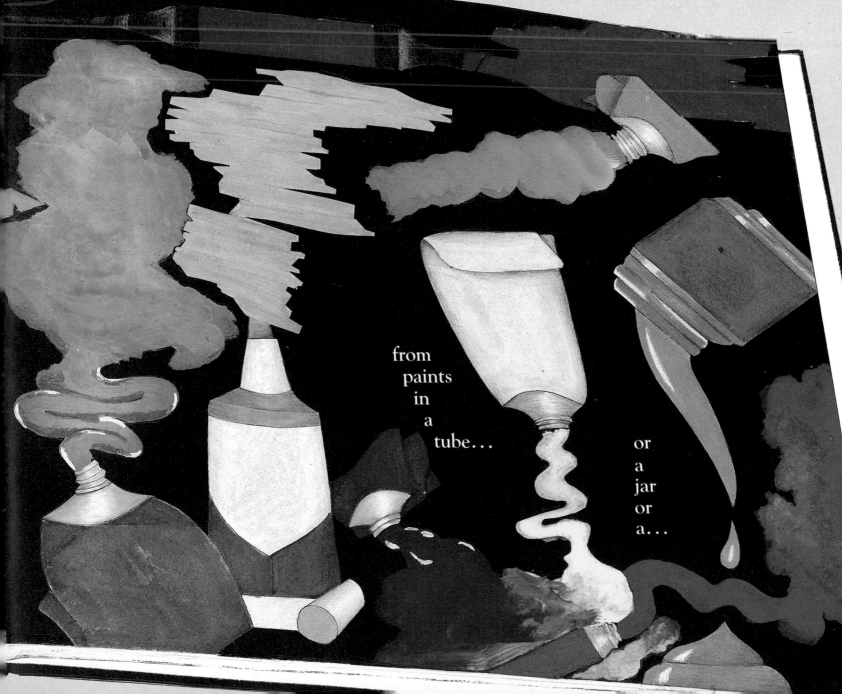

from
paints
in
a
tube...

or
a
jar
or
a...

Stage
one
is
yellow;

magenta,
stage
two.

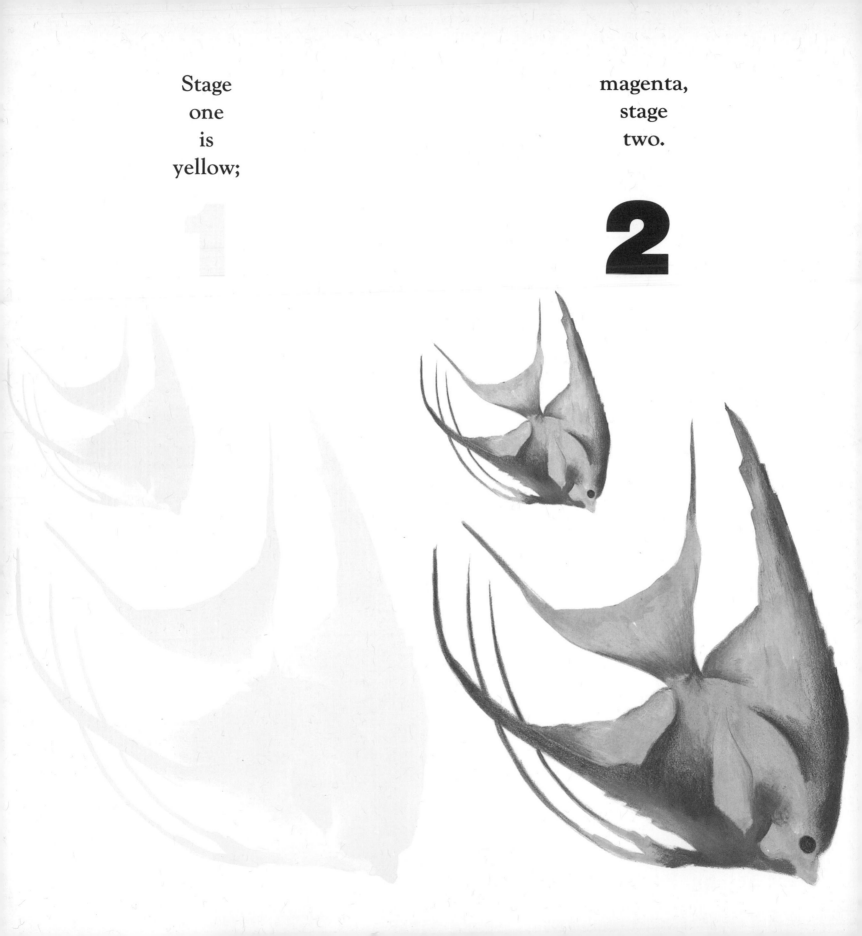

Stage
three,
like the sea,
is cyan blue.

3

Black
is stage four,
and the printers
are through.

4

The printers are
some kind of wizards,
I think.

In miniscule
dots they apply
all the ink.
They apply
all the
ink to a
surface
that's
white.

HOKUS
and
POKUS—
Behold!
What a
sight!

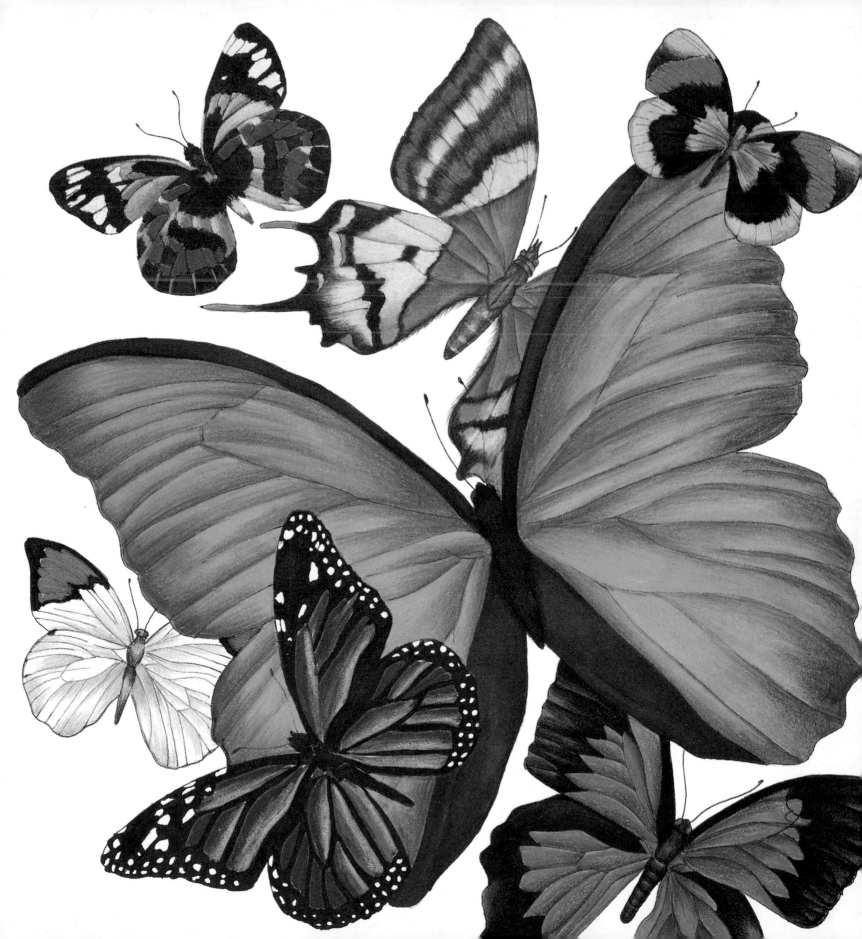

Black plus these primary colors, comprise the only **4** inks any printer applies.

We call **black** a color, but that's problematic.

Black
should really
be
called ...

ACHROMAT·IC·

ach·ro·mat·ic (ak′re mat′ik),
adj. free from color.

So yellows . magentas

and the combination of any two produces a secondary hue.

. . . and cyan blues are the primary hues that printers use,

The secondary colors seen are—PRESTO and CHANGE-O—
orange, purple, and green.

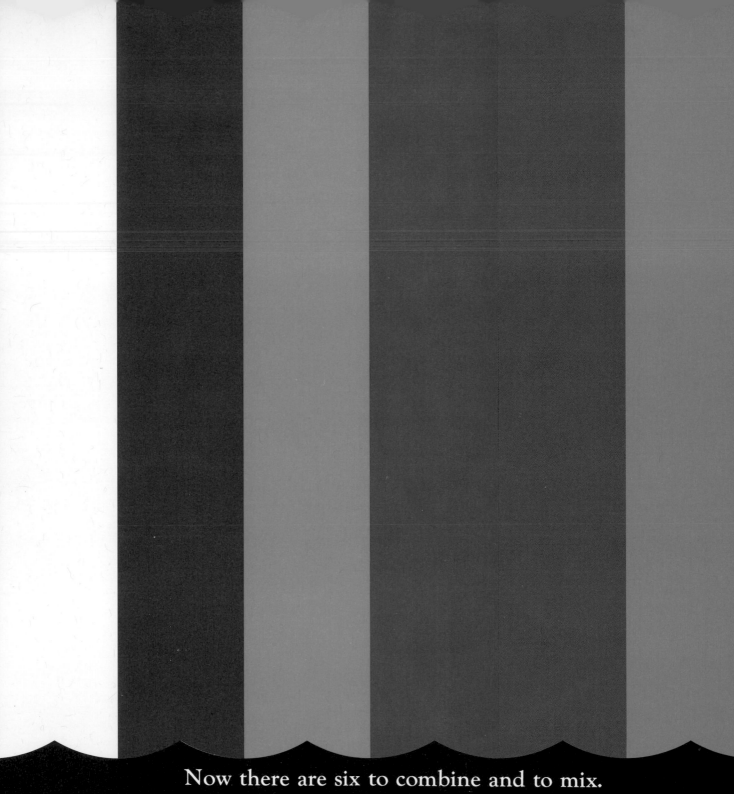

Now there are six to combine and to mix.
The colors continue their magic tricks

Mix red with
a color
to make it
warm,
and
blue
to make it
cool . . .

and
if you
follow
this
very same
rule,
blues
become
warm,
and reds
become
cool.

Cool colors
recede,
and
warm ones
advance.

Some colors together vibrate and dance.

Mix opposites
on this
wheel of color...

the splendor is gone ... and the color gets duller.

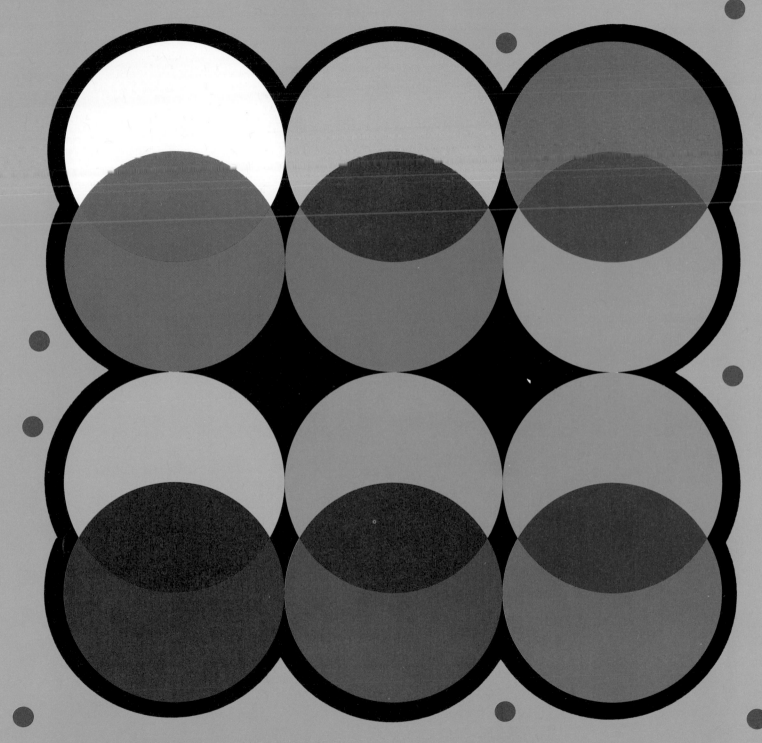

Opposites on that wheel, you see ... are always called ...
COM•PLE•MEN•TA•RY.

Now
stare at
the green
and
stare at
the pink,
and
count to
30
and
try not to
blink.

Then
shift to
the right
and stare at
the white.

The colors
have
switched.

Comple-
men-
tary
colors
are . . .

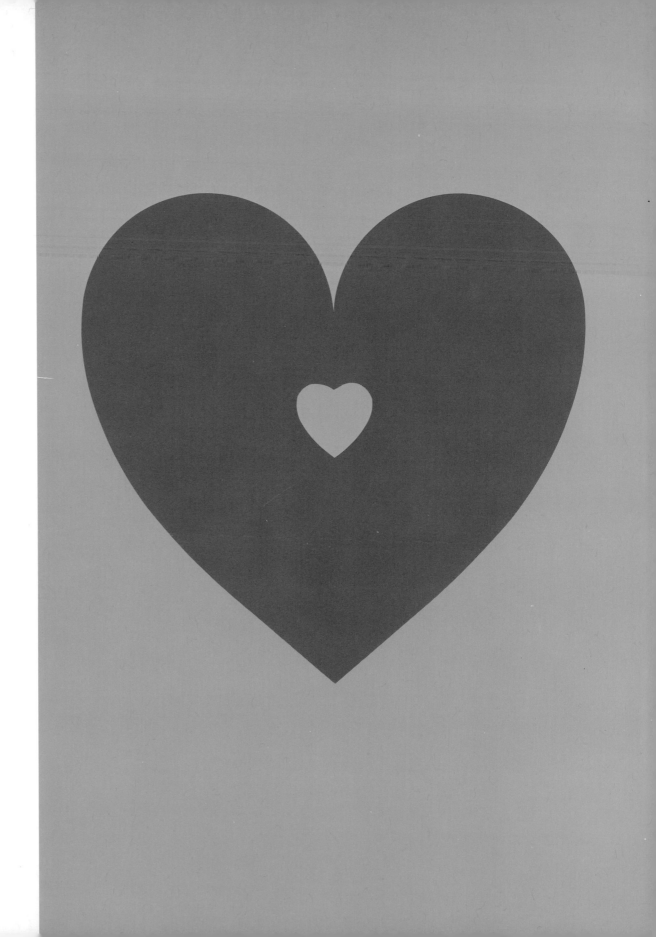

truly
bewitched.

It's the
weirdest
thing
I have ever
seen.

The
green is
pink,
and the
pink is
green.

Color
is
magic . . .
no doubt
about
that.

If
you're
not
convinced . . .

I'll
eat
my
hat!